EVA DUTTON is a professional artist and qualified horse-riding instructor and stable manager. She has spent many years combining her love of painting with her professional equestrian work. As well as her love for horses, she has a passion for wildlife and landscapes.

SUSIE HODGE has written over 100 books on art, art history and artistic techniques. In addition, she hosts lectures, talks and practical workshops, and has regularly appeared on television and radio.
www.susiehodge.com | Instagram: @susiehodge1

JONATHAN NEWEY is an award-winning artist with extensive experience in many drawing and painting mediums including coloured pencil. He has many drawings and paintings in collections both nationally and internationally.
www.jonathannewey.com

POLLY PINDER studied graphics at college, and has written and illustrated a number of books on a variety of subjects including cake decoration and growing herbs, papermaking and papercrafts.

Other books by the authors:

Also in the Draw 30 Series:

Draw 30
Animals
in easy steps

Polly Pinder, Susie Hodge, Eva Dutton and Jonathan Newey

Search Press

About this book

Each of these 30 animal and bird drawings has no more than eight simple steps: the first shape is drawn in a single colour, then new shapes are added in different colours to build up the picture. Black lines are used for the final drawing, then the completed image is fully coloured.

Grab some paper, a pencil (HB, B or 2B) and an eraser and get started. When you feel confident about your drawing, you can introduce colour, using watercolours, coloured pencils, acrylics or pastels.

Pick and choose your favourite animals and birds, or work all the way through the book.

The contents

The Drawings

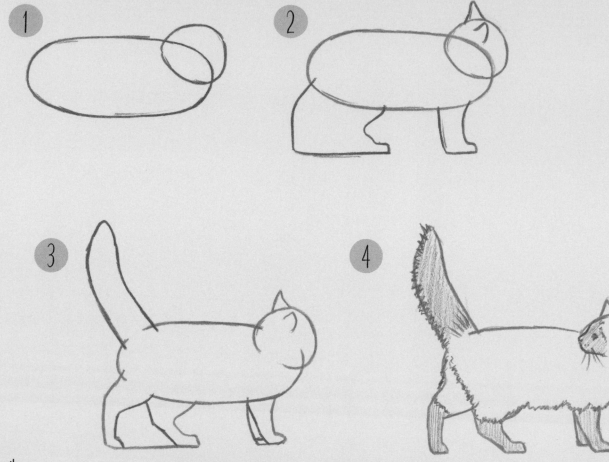

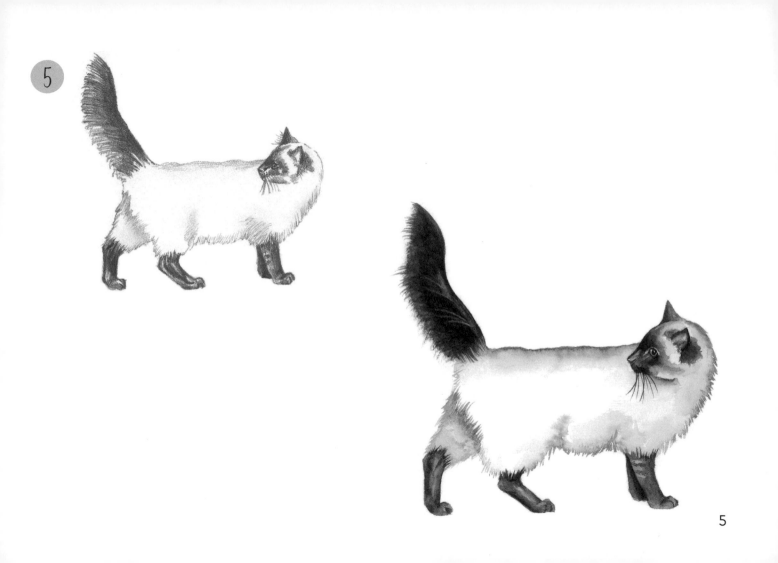

5

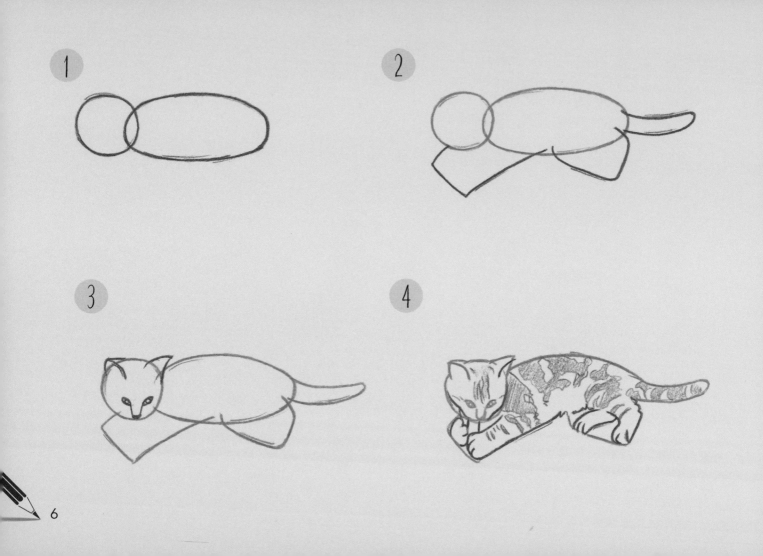

1

2

3

4

6

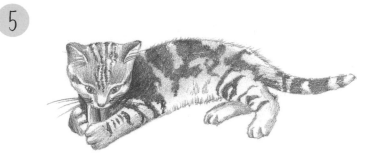

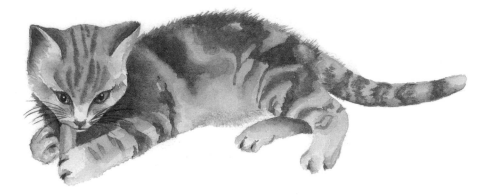

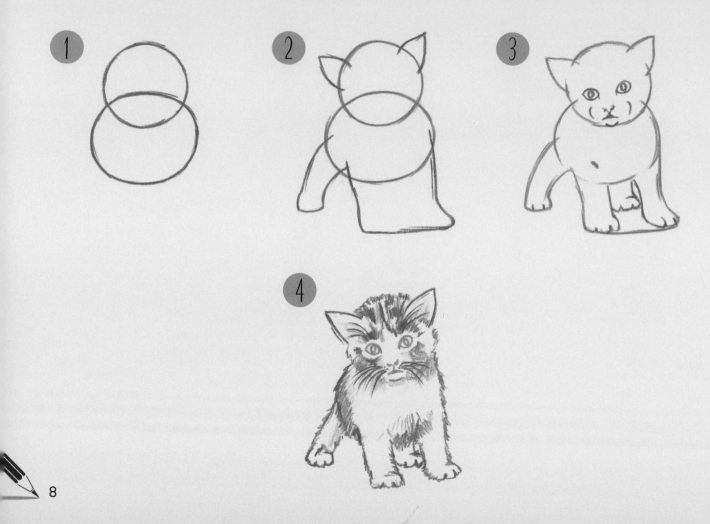

8

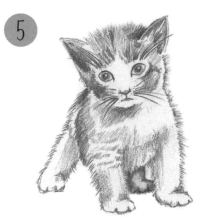

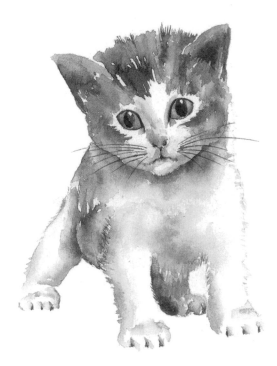

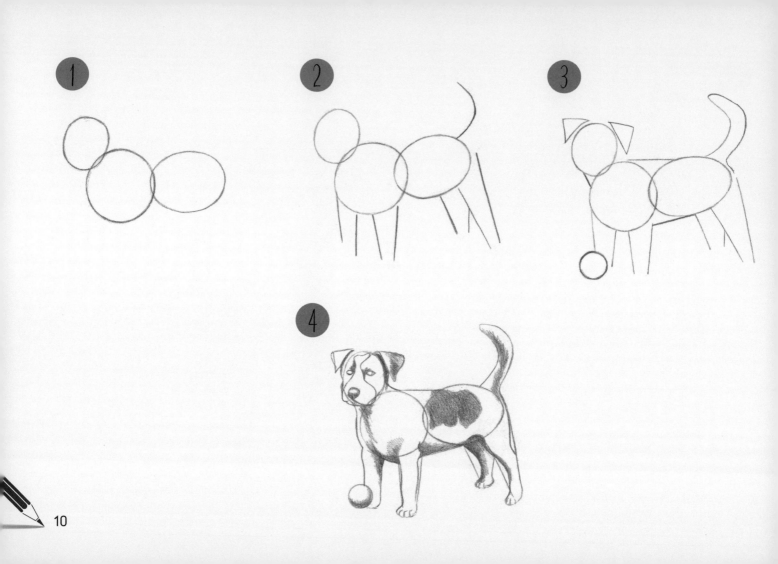

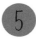

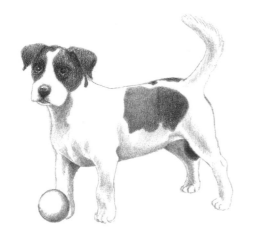

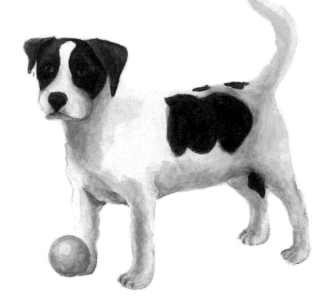

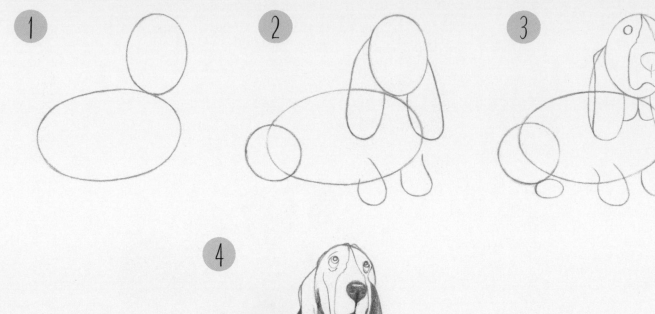

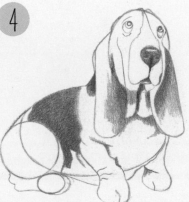

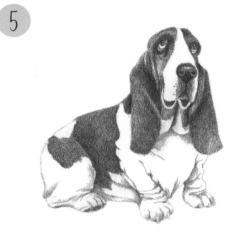

5

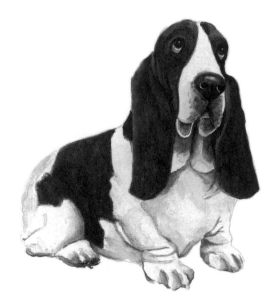

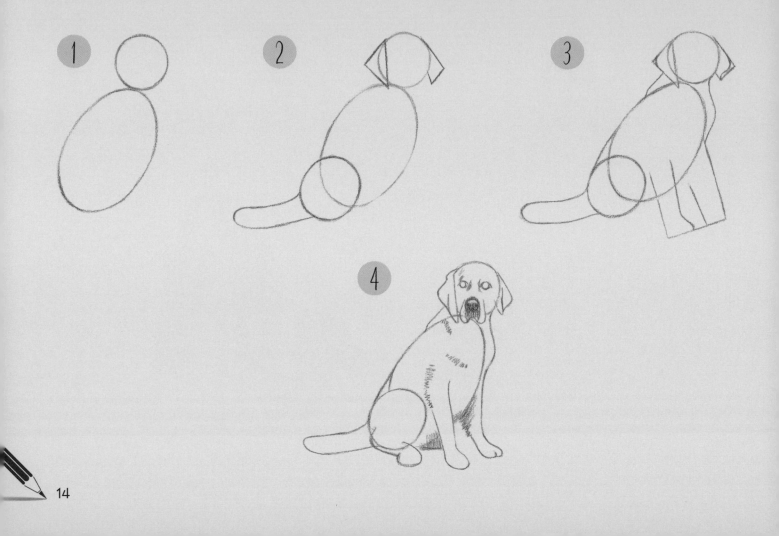

14

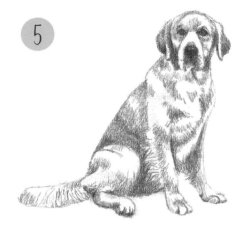

5

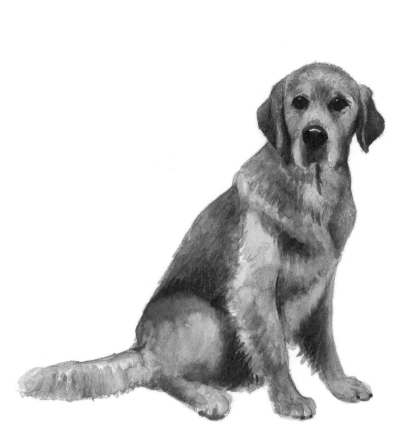

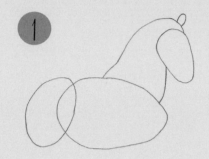

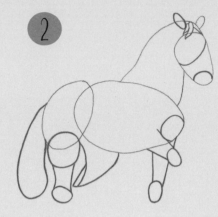

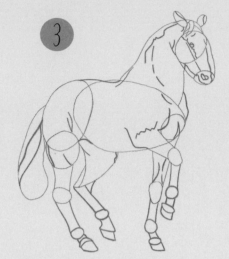

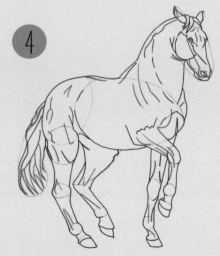

16

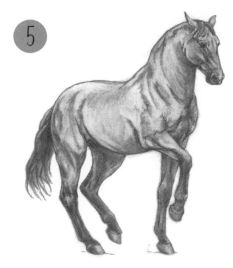

5

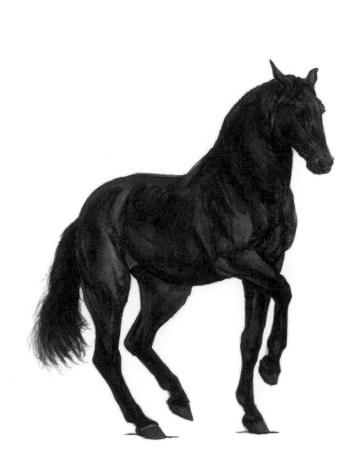

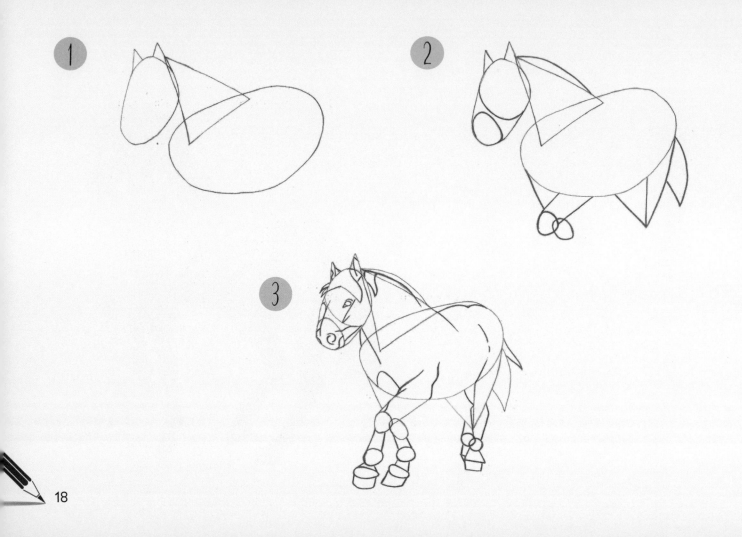

18

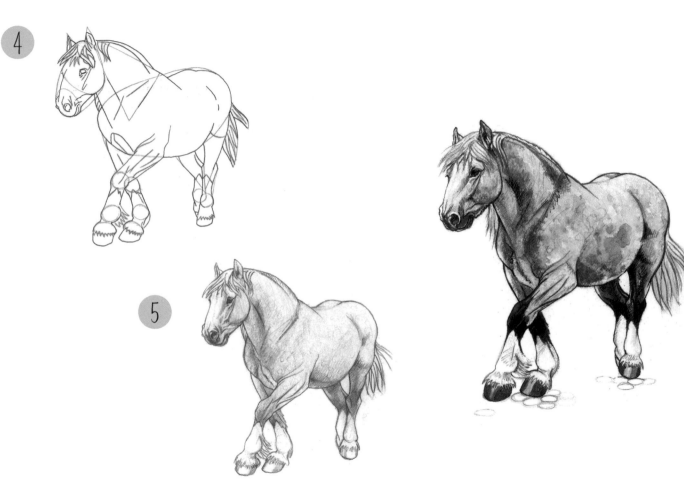

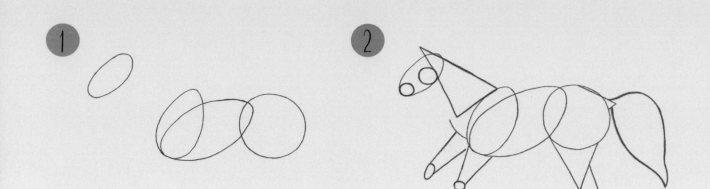

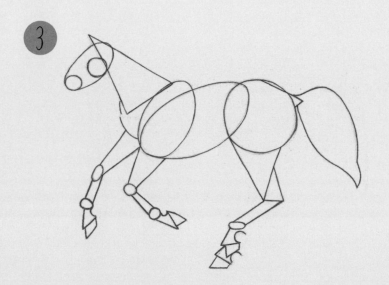

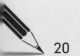

20

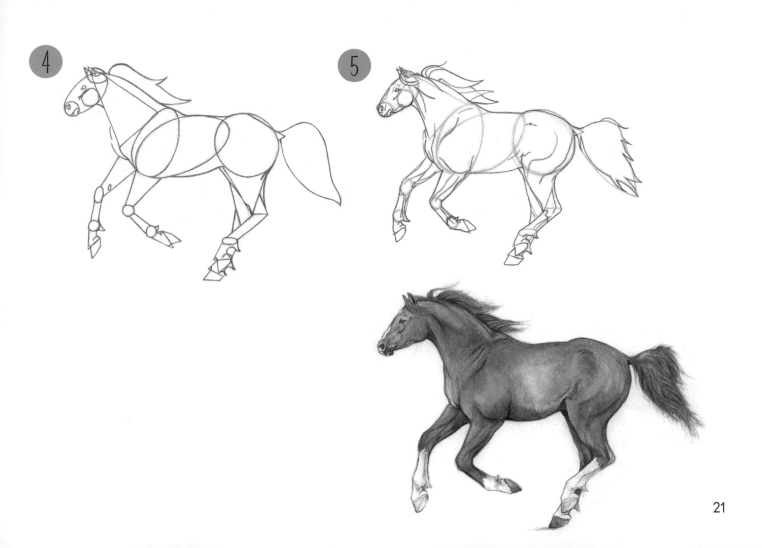

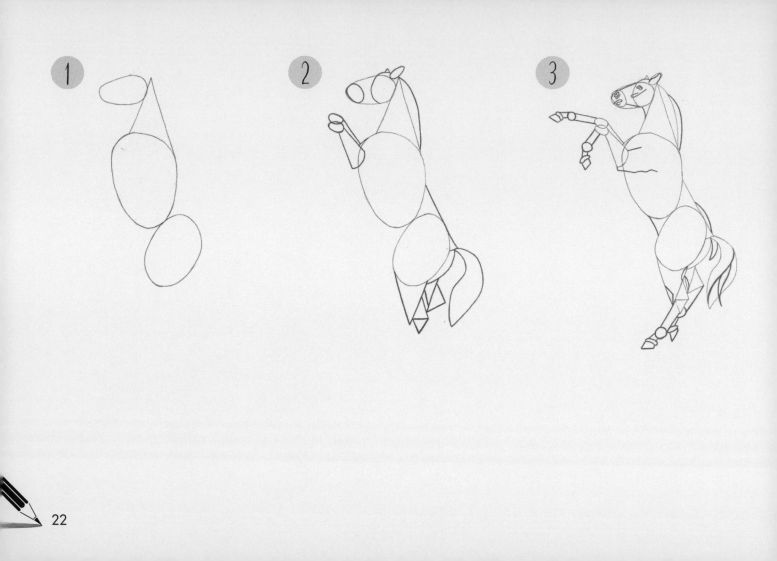

22

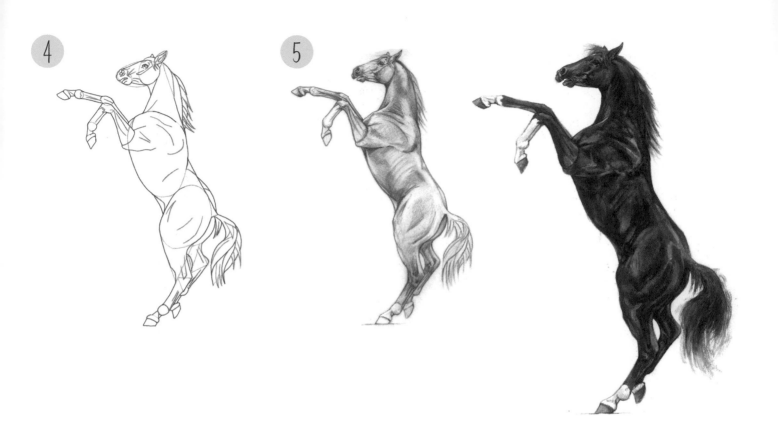

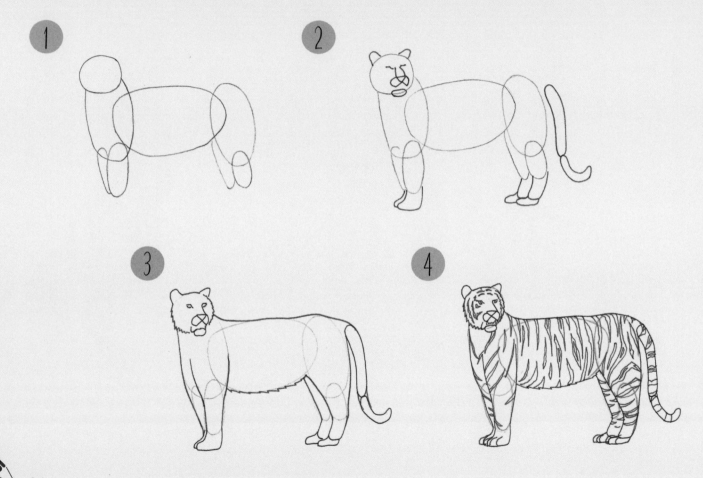

24

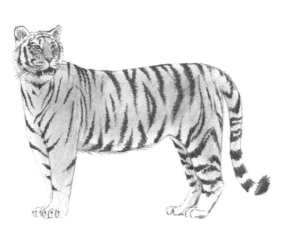

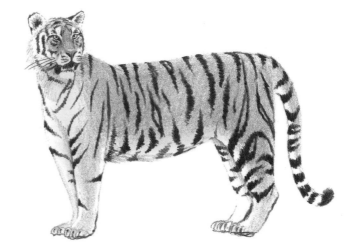

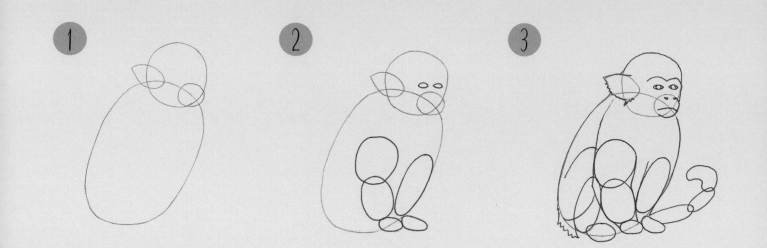

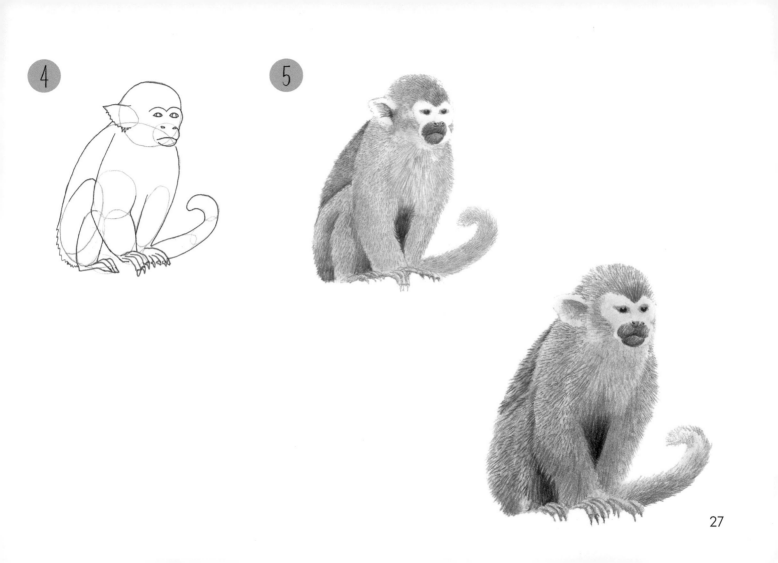

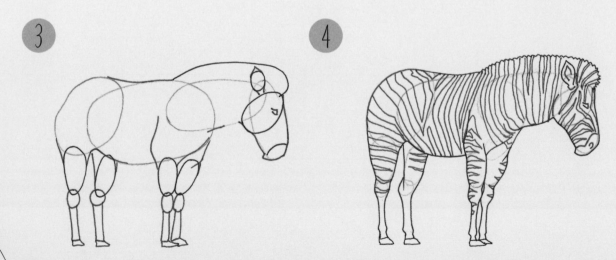
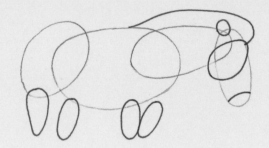

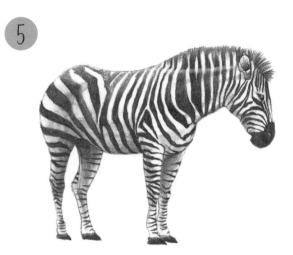

5

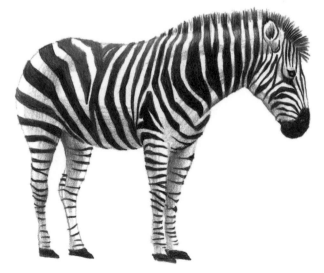

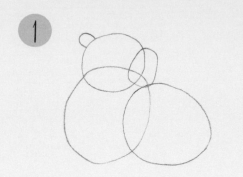

1

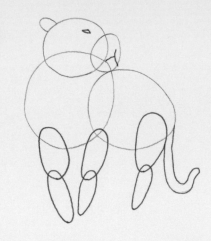

2

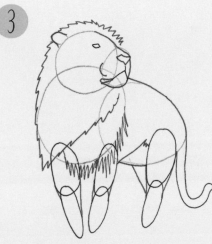

3

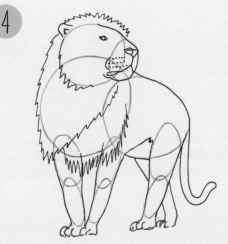

4

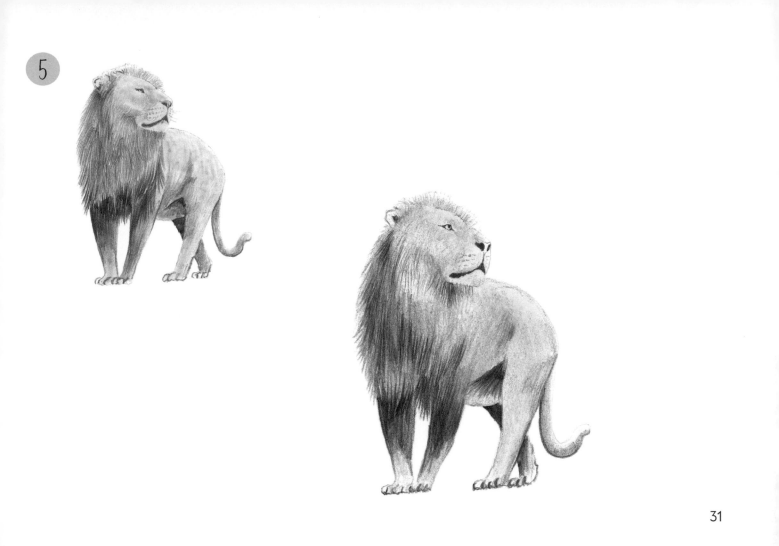

5

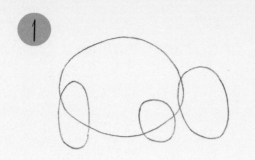

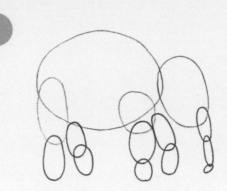

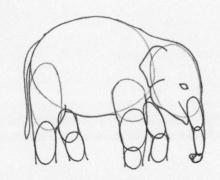

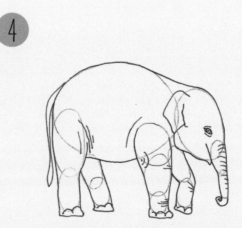

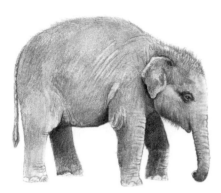

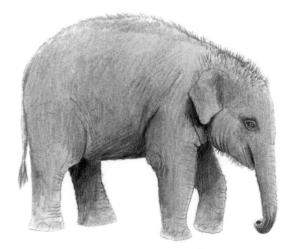

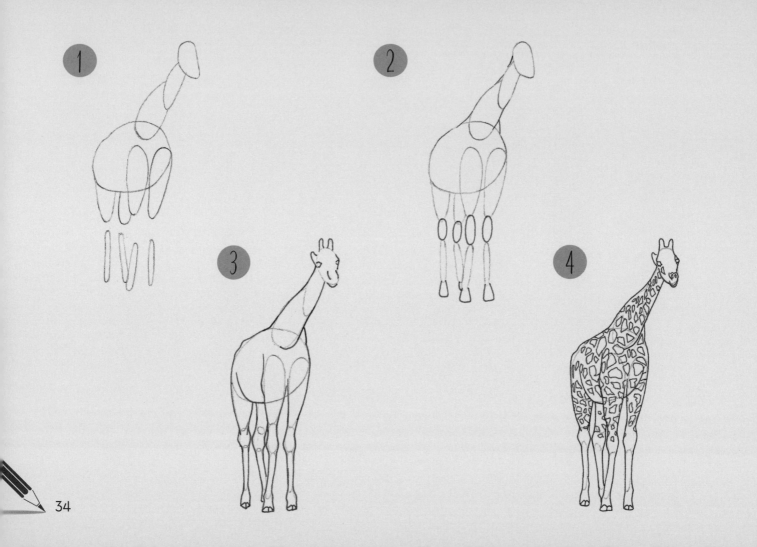

34

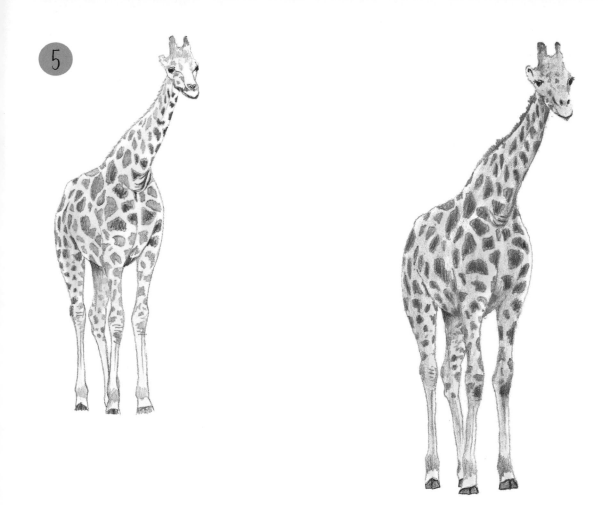

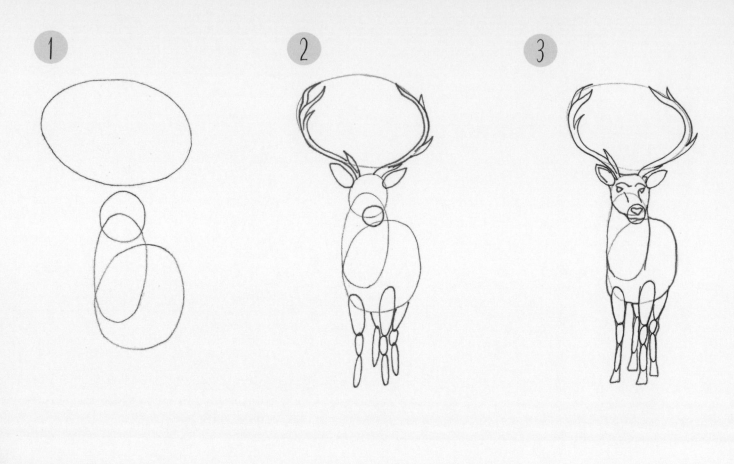

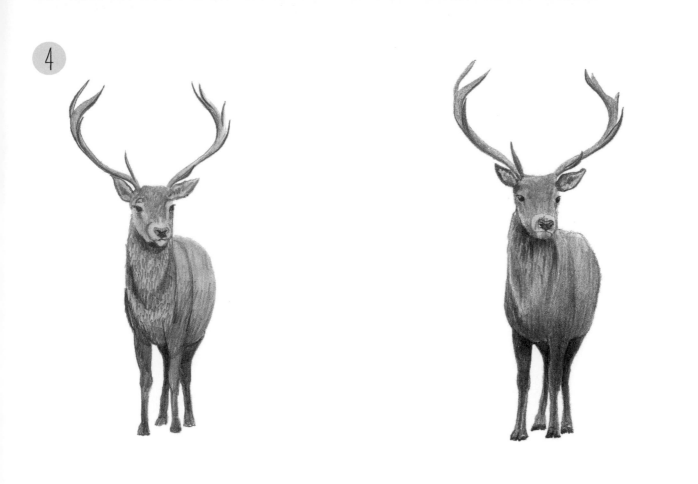

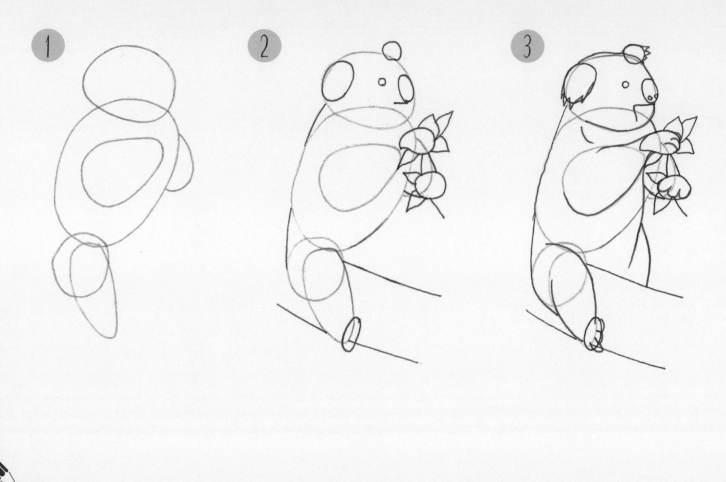

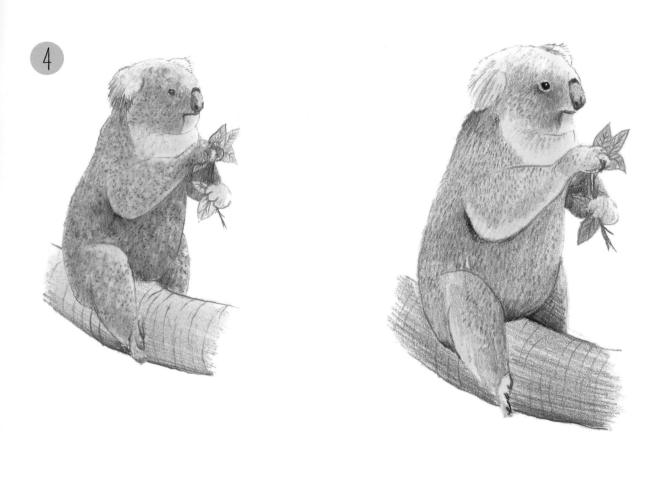

4

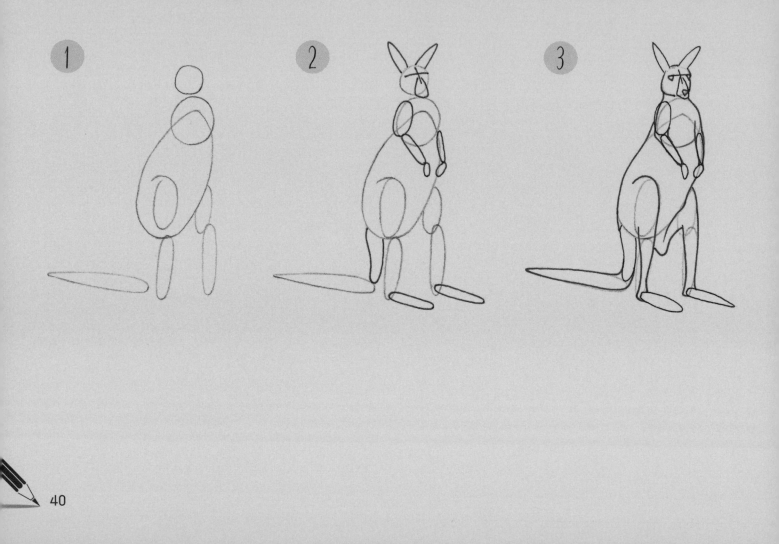

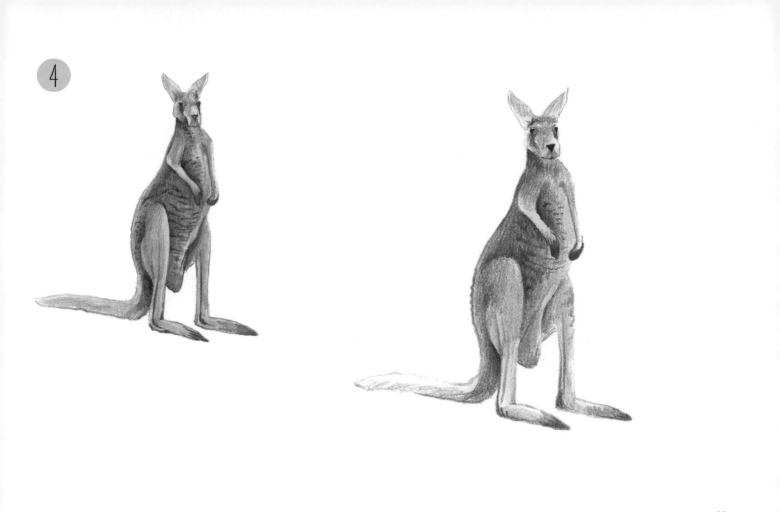

4

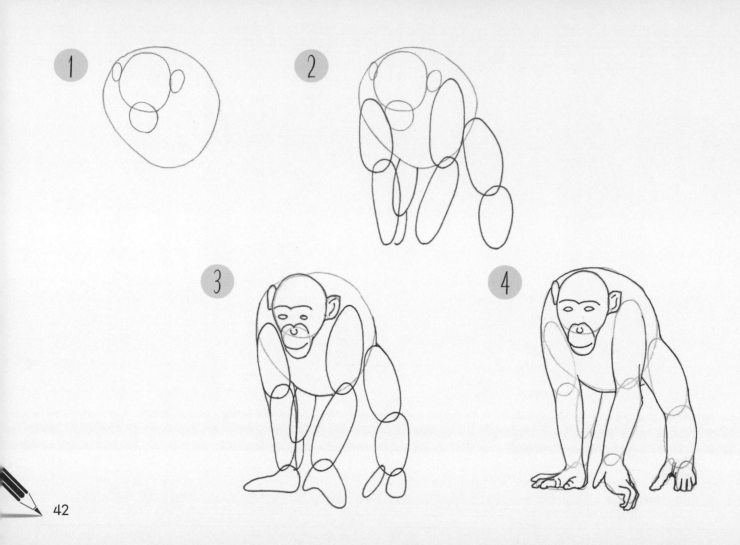

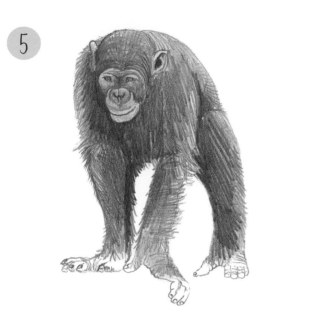

5

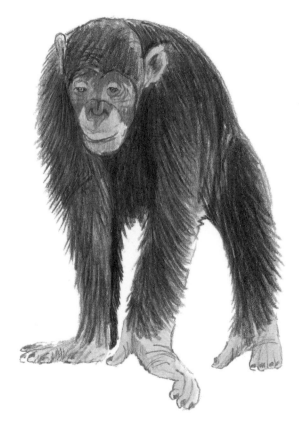

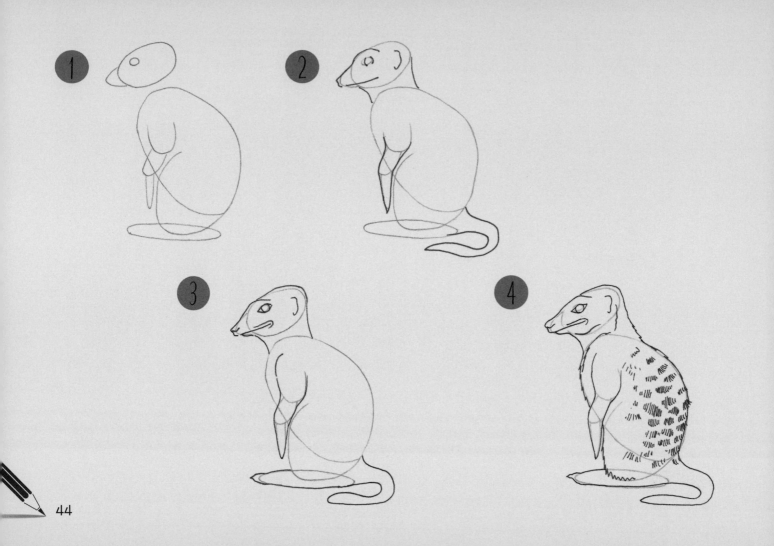

44

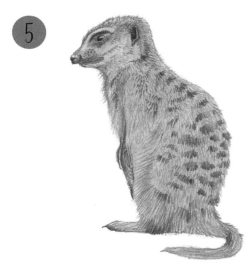

5

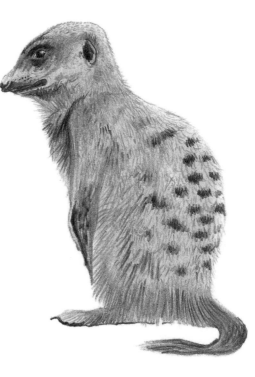

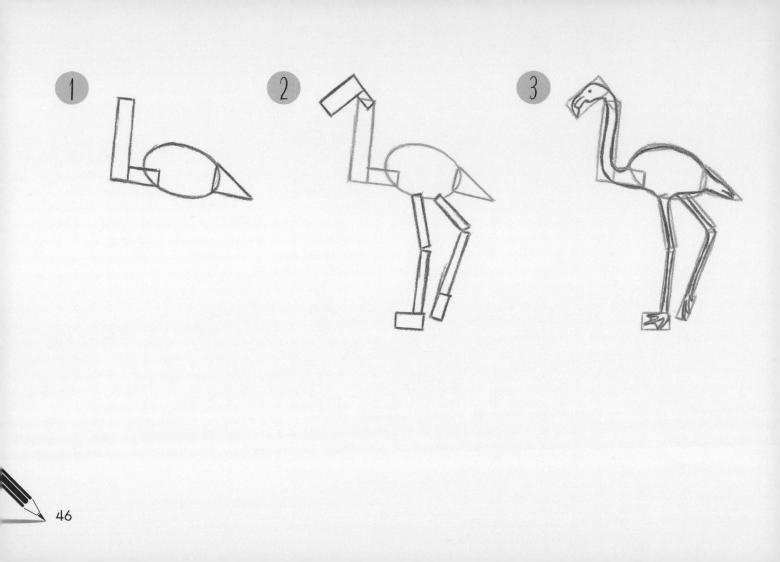

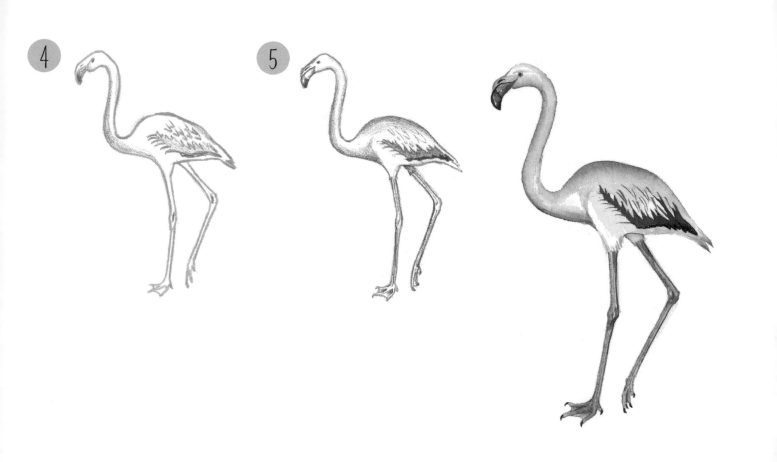

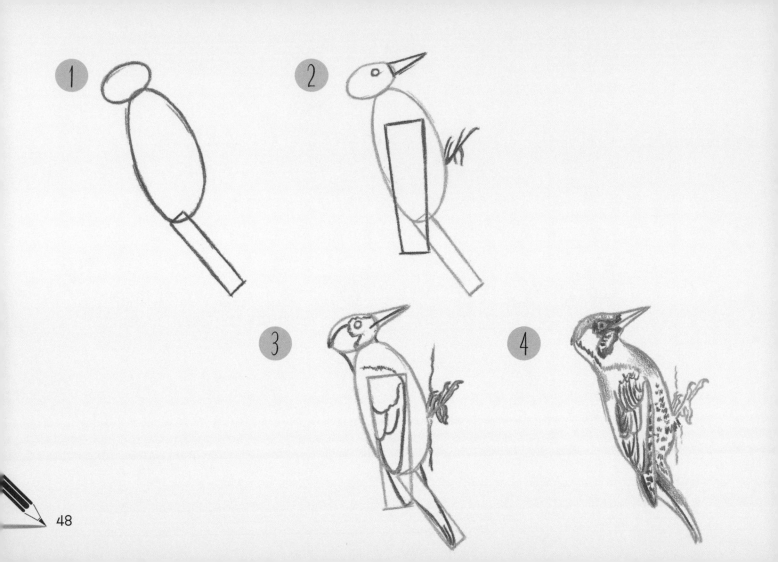

48

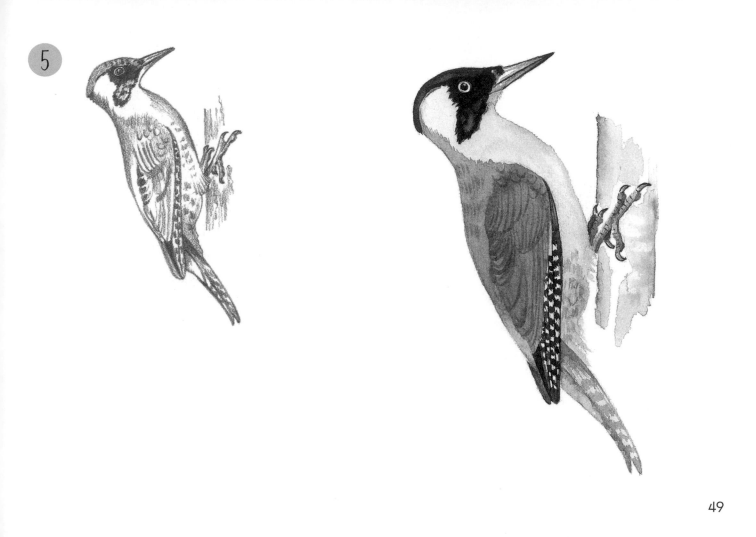

5

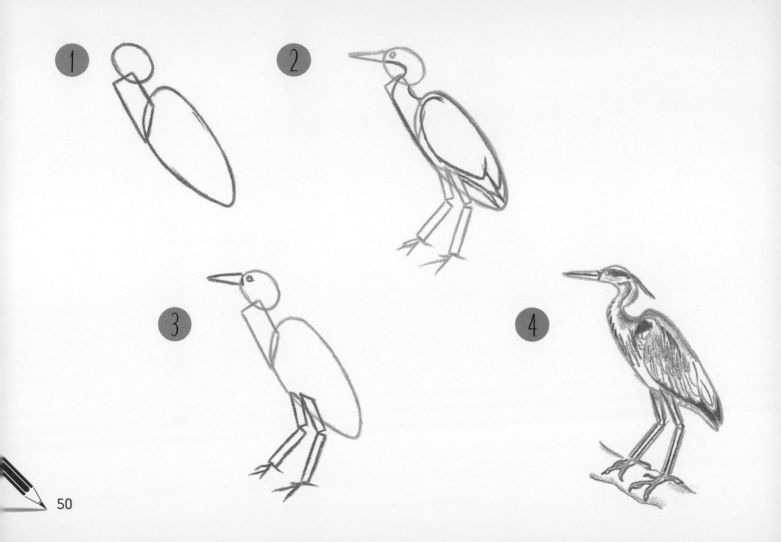

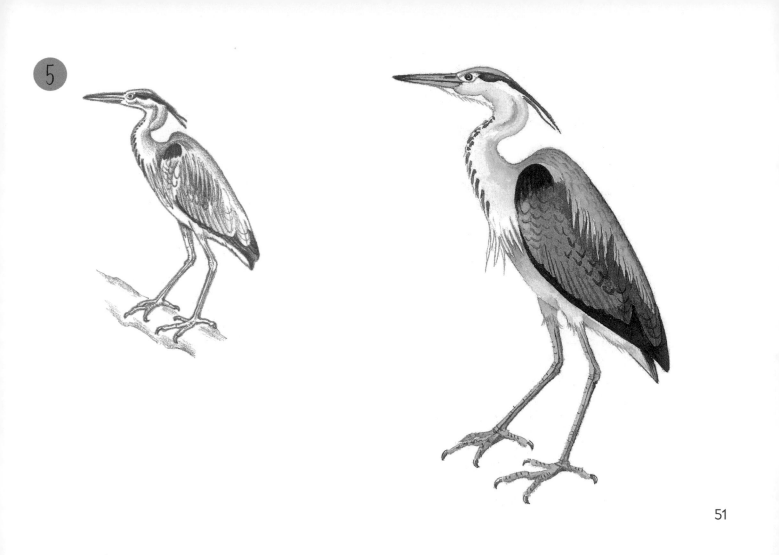

5

51

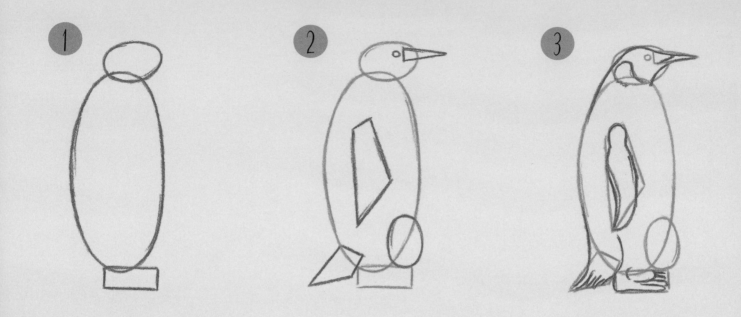

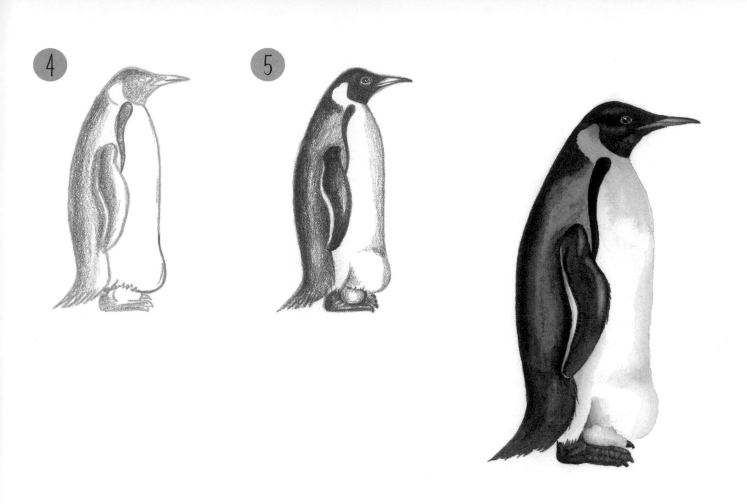

53

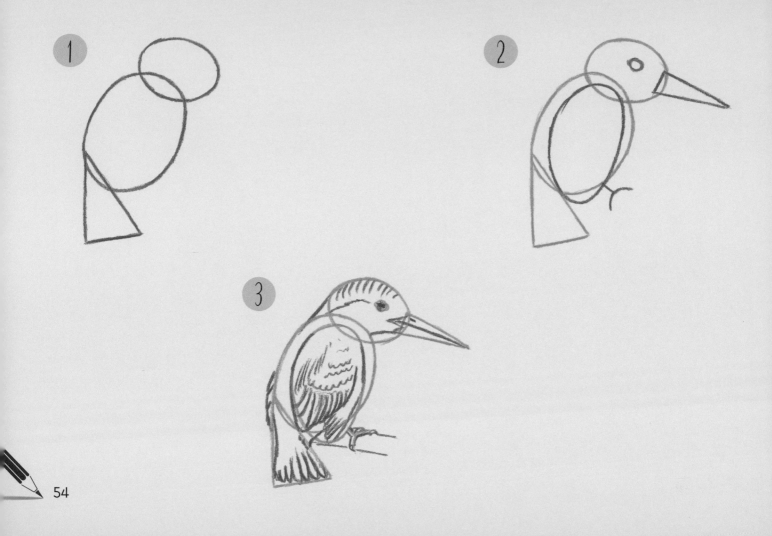

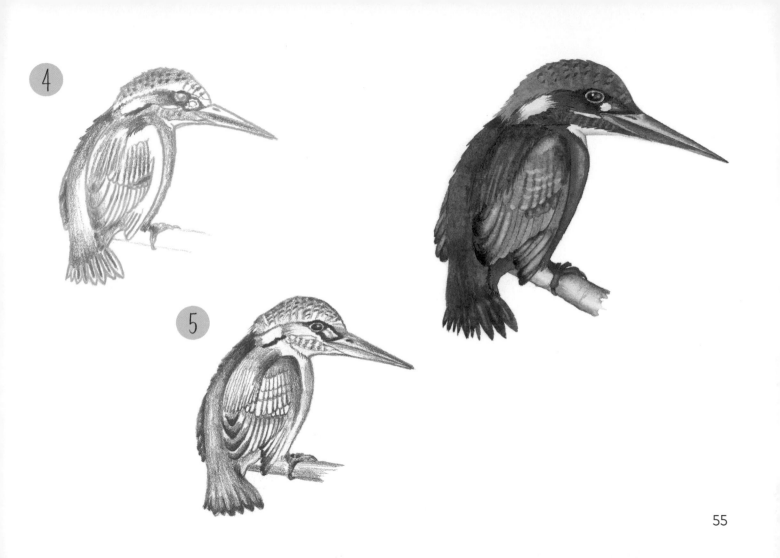

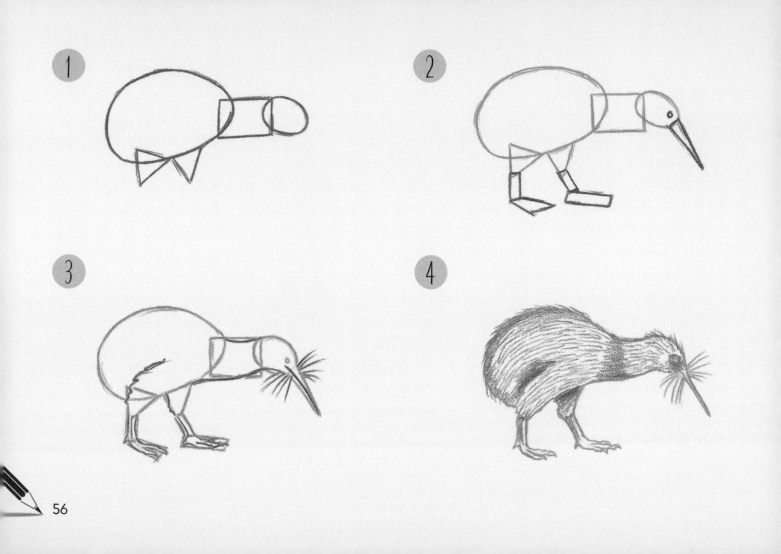

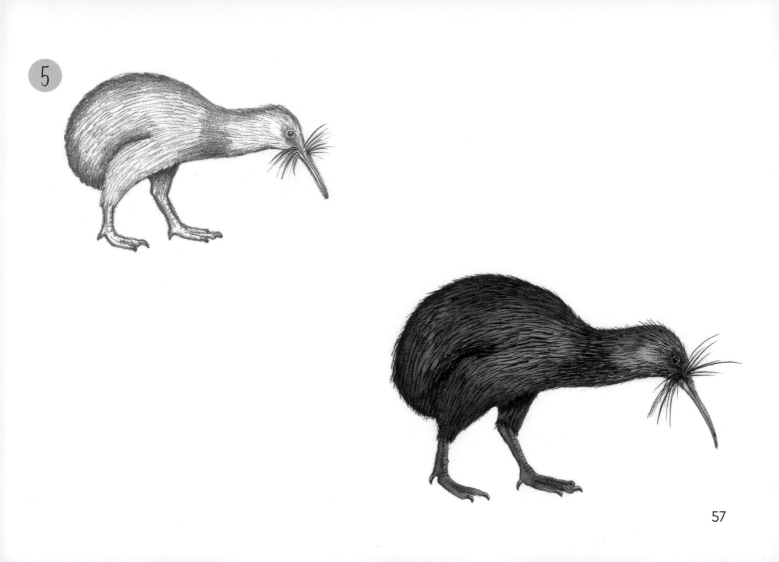

5

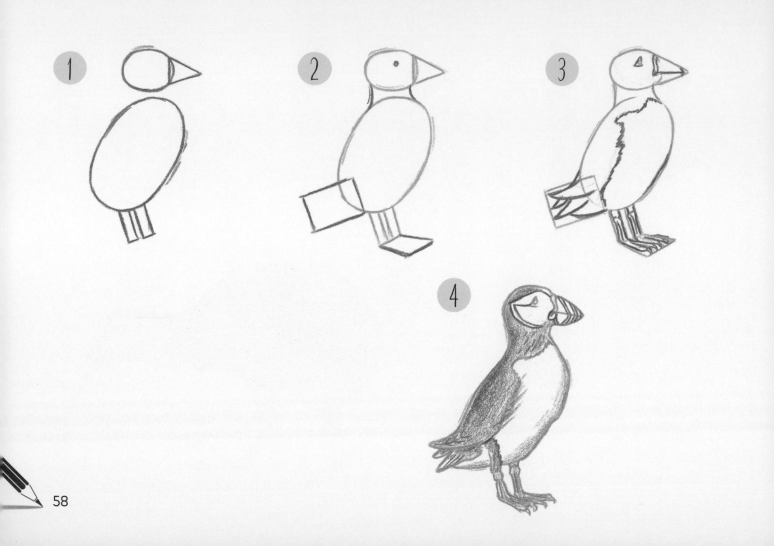

58

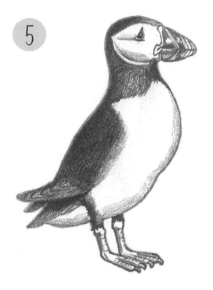

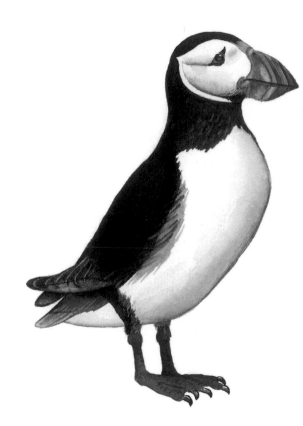

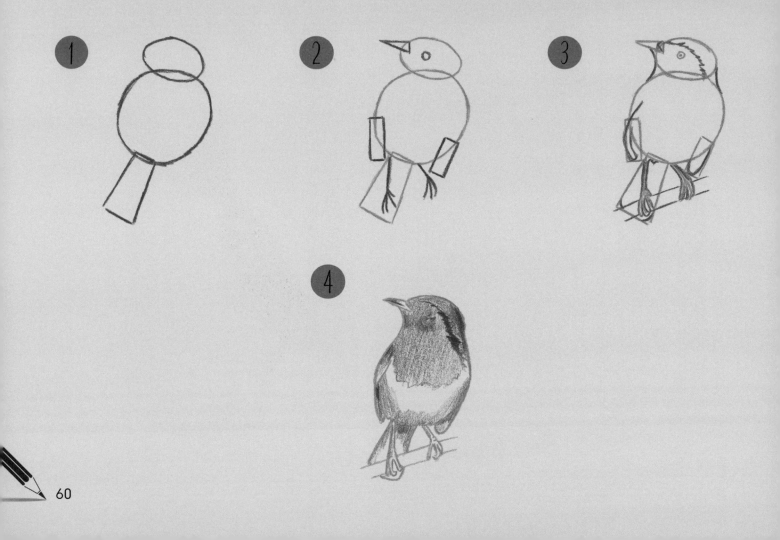

60

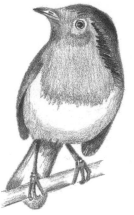

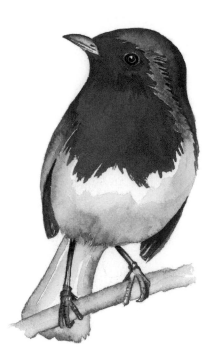

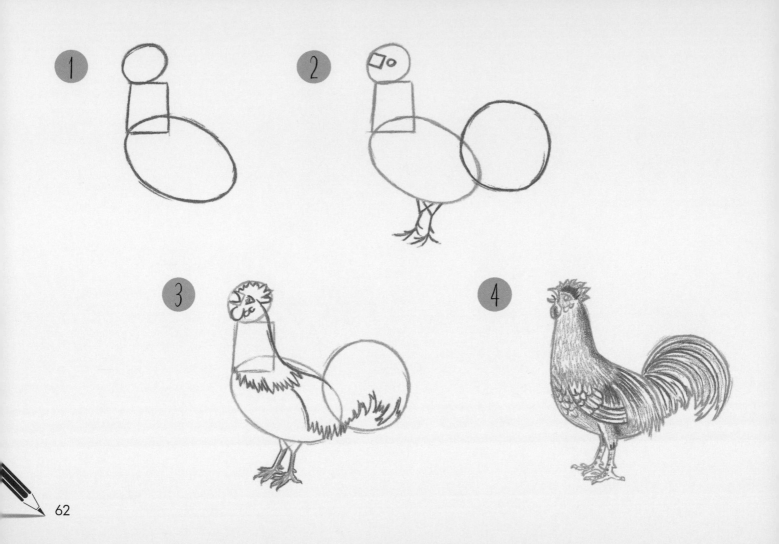

5

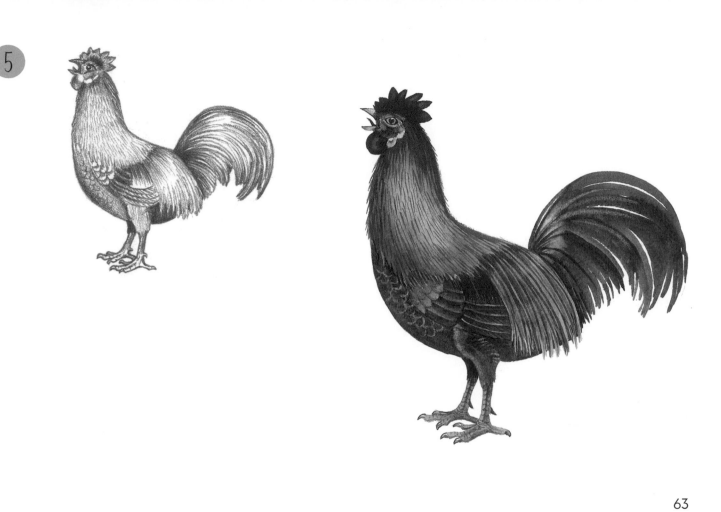

First published in 2024

This book uses material previously published in:
How to Draw Cats, Polly Pinder, 2008, pages 4–9
How to Draw Dogs, Susie Hodge, 2009, pages 10–15
How to Draw Horses, Eva Dutton, 2009, pages 16–23
How to Draw Wild Animals, Jonathan Newey, 2010, pages 24–45
and *How to Draw Birds*, Polly Pinder, 2008, pages 46–63.

Search Press Limited
Wellwood, North Farm Road,
Tunbridge Wells, Kent TN2 3DR

ISBN: 978-1-80092-183-2
ebook ISBN: 978-1-80093-169-5

For further ideas and inspiration and to join our free online community, visit www.bookmarkedhub.com

FSC
www.fsc.org

MIX
Paper | Supporting
responsible forestry
FSC® C016973

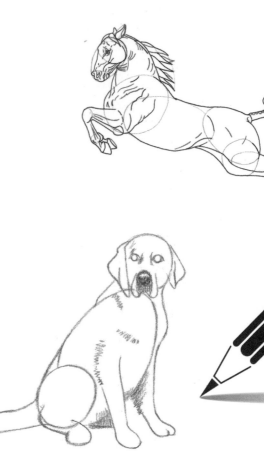